CHAPTER III

Reward!

The big poster offering a reward for the capture of the train robbers so fascinated Annie that she kept going back to it and reading the particulars over and over again. Five thousand dollars was now offered for the bandits or any information leading to their capture—dead or alive.

"Five grand!" Annie repeated,

46

who had found and adopted him

We see him now, as the story opens, running toward the porch of the house, a letter in his hand.

"From Tracy," he shouts gleefully. "The hired man just brought it from the city."

He reads the letter to his blind father.

"And Pat and the Chief," Tracy writes, "send their regards. We all talk about you, Kid, and miss you. But we know you're in a great spo

SEE A FIGHT
TO THE FINISH!

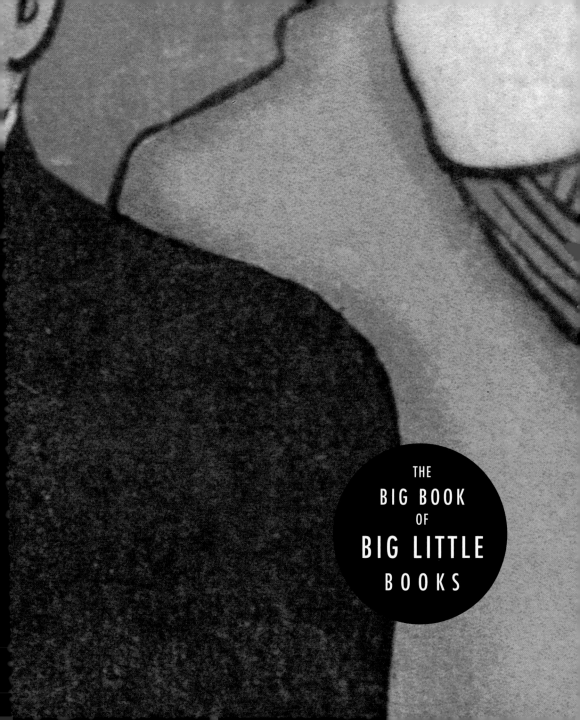

THE
BIG BOOK
OF
BIG LITTLE
BOOKS

The Big Book
of
BIG LITTLE BOOKS

★

by Bill Borden

with Steve Posner

CHRONICLE BOOKS

SAN FRANCISCO

Dedicated to Melinda, Alex, and Gabriel

Whitman®, Whitman Big Little Book®, Big Big Book™, and
Big Little Book® of © Golden Books Publishing Company, Inc.
Used by permission.

Printed in Hong Kong
ISBN 0-8118-1741-5

Library of Congress Cataloging-in-Publication Data available.

Book and cover design: Werner Design Werks, Inc.
Cover photography: Darrell Eager
Interior photography: Bill Borden

Distributed in Canada by Raincoast Books
8680 Cambie Street
Vancouver BC V6P 6M9

10 9 8 7 6 5 4 3 2 1

Chronicle Books
85 Second Street San Francisco, CA 94105

Web Site: www.chronbooks.com

CONTENTS

CHAPTER PAGE

 Preface. 6

 Introduction. 9

 Author's Note. 15

 I Funnies 17

 II Space 35

 III Adventure 45

 IV Movies 59

 V Crime. 77

 VI Wild West 97

VII Aviation 107

 Illustration Index. 116

 Subject Index. 119

It is truly amazing how a memory stored in the deep recesses of the mind for many decades can be returned to consciousness in vivid detail by a simple reminder. You are holding in your hand a book of memories. This personal collection of Bill Borden's BLB's has been lovingly arranged and formatted with artistic care. It spans much of his lifetime, and it probably links with segments of your own.

As I glanced over the array of beautiful cover illustrations, many of my seemingly forgotten memories of childhood leaped into my consciousness. Like the time I stood in front of a rack of BLB's at the Woolworth Five-and-Dime

Store, trying to choose just one title upon which to spend the single Depression-era dime I held between my fingers. Unlike flimsy comic books that were quick-reads like today's tabloids, BLB's had book-like format and substance. If you ever held one in your hands, you've never forgotten the experience.

As you look through this book, let those fond, cherished memories return. They will be links held in common with Bill and many other readers whose lives were touched by these uniquely formatted little books.

Professor Lawrence Lowery
University of California at Berkeley
President, Big Little Books Collector's Club

"If My Experiments Succeed—"

During the summer of 1994, I produced the movie, *The Cure,* in a small, turn-of-the-century Minnesota town called Stillwater. Stillwater is a beautiful town with wonderful family neighborhoods, so during the filming I brought along my wife and children, two boys ages seven and one. Our oldest son, Alex, was learning to ride his bike, and it was fun to see him zip by with a gang of other kids while I was on the movie set. My memories of growing up in a small neighborhood learning to ride my bike vividly came back to me. Several weeks into the shoot another event occurred that brought back even more memories and started me on a whole new adventure.

Dick Tracy on Voodoo Island, Chester Gould, 1944

Flash Gordon on the Planet Mongo, Alex Raymond, 1934

Stillwater's small historic downtown is filled with specialty bookstores and antique shops. In one of these shops I found a style of book that I hadn't seen or held in 30 years. In a wood case, under glass, I noticed a *Buck Rogers* Big Little Book. Next to it were three others: *Tom Mix, Flash Gordon,* and *Tarzan.*

Memories came flooding back to me of the great moments I had lingering over each left-hand page with its oversized text while I sneaked looks at the illustrations on the right-hand page. Most of these small, cardboard-bound "book sculptures"—just $3\frac{5}{8}$ inches wide, $4\frac{1}{2}$ inches tall, and $1\frac{1}{2}$ inches thick—contain hundreds of pages of text and

illustrations. A child, or even an adult, can follow the exploits of their favorite characters in words and drawings. I bought all four of these little books, learning later that I had overpaid in dollars, but not in appreciation.

Somehow, when I was a child, the simple black-and-white drawings, combined with the printed word, created a whole new world for me. They opened my imagination far more than any other books I had read. I must admit, even today, when I look over at the right-hand page of a book, I miss seeing a drawing there. What was their magic? Were these illustrated books a precursor to my interest in making movies? Did they lead to

my interest in collecting both art and books?

As a result of buying those books in Stillwater, I pursued collecting this style of book with a passion. I found that the first Big Little Book, *The Adventures of Dick Tracy,* was created and trade-marked in 1932 by the Whitman Publishing Company of Racine, Wisconsin. Six years later they changed the name of their books to Better Little Books.

Many other publishers jumped on the bandwagon and created their own versions of small, thick, picture books, but none reached the volume of publications produced by Whitman.

Dell Publishing Company of New York, in arrangement with Whitman, produced a series of "Fast Action" books with Whitman characters, such as Dick Tracy and Flash Gordon.

Goldsmith Publishing Company of Chicago produced several books known as the "Radio Star Series" with storylines built on radio personalities such as Eddie Cantor, Jack Pearl, and others.

The World Syndicate Publishing Company took all its subjects for its books from events in United States history, featuring personalities that included Kit Carson, Buffalo Bill, and Daniel Boone.

The Engel-van Wiseman Book Corporation called their books "Five Star Library Series" and based all their content on movies: *Little Minister* with Katherine Hepburn, *Robin Hood* with Douglas Fairbanks.

Lynn Publishing of New York also used movies as the content for most of their "Lynn Book" series. Two exceptional ones were *Tale of Two Cities,* featuring Ronald Coleman, and *O'Shaughnessy's Boy,* with Wallace Berry and Jackie Cooper.

Saalfield Publishing Company, which published some of my favorite titles, was Whitman's biggest competitor. Starting in 1934, they eventually published hundreds of titles from a wide range of subjects under the trademarked title of Little Big Books. They too did movie books, including Hal Roach's *Our Gang* characters, *The Little Colonel* starring Shirley Temple, and *It Happened One Night* with Clark Gable and Claudette Colbert. They also published several Popeye books and many cowboy stories.

The artistic heyday of publishing for this type of book was the 1930s and 1940s, but hundreds were published later. Although the formats and series names varied slightly over the years with each publisher, Whitman's original tradename, Big Little Books, seems to have stuck with collectors and is now almost the generic name for these kinds of books. These days, they are often just called BLBs.

I have been asked several times how many BLBs were made. The answer is difficult because there are variations on the format that could or could not be considered a BLB, but my best estimate is that about 1,100

small, similar style books were published in the first twenty years following the original Whitman book.

The early BLBs somehow seem to transcend being just books. Each one has become an object of art. Small, blocky, and colorful, the books have the aroma and yellowish glow of old newsprint, and they hold the promise of adventure, laughter, and love. I relish holding them in my hands, or just looking over and seeing these thick little books sitting on my shelves.

I have always wondered if their size made them more intimate, allowing me to create stories with my imagination that emerged directly from the pages themselves. Leonardo da Vinci once said that one can create better in a small room than in a larger one where the mind can wander. Does that apply to small books too? Did these small books, which are only slightly larger than a child's hands, make it easier for their young readers to hold them, to appreciate them, and then to imagine?

While preparing this book, I actually became stalled more than once as I found myself reading the darned little things. *Gee, Flash Gordon is about to be captured if he stops to kiss his girlfriend, Dale; but heck, maybe he'll get away with it? Oops! He didn't.*

I wish I would have saved my BLBs from when I was a kid in the '50s. I should have, for I would have also saved a lot of money in the last few years. The value of these little "sculptures" have appreciated just like real pedigree art. Originally, the publishers sold their books for about 10 to 15 cents, and now, depending on their popularity and condition, they sell for anywhere from $20 to $1,000.

The emphasis of this book is on the covers of the BLBs from my collection of over 500 books. It is not intended as an academic study or a comprehensive review. Some of the BLBs and their covers aren't in perfect condition, but neither are my memories.

Bill Borden

The stories and characters contained in these books are taken from movies, radio, and popular characters, but most of them have their origins in previously published daily syndicated newspaper comics. After a newspaper series had reached a certain fame, publishers licensed the cartoon drawing reprint rights to those series, combined several months of work into one story, wrote new text and put them out in this format. Many times the original drawings had to be altered to fit the format: dialogue balloons removed, drawing dimensions altered.

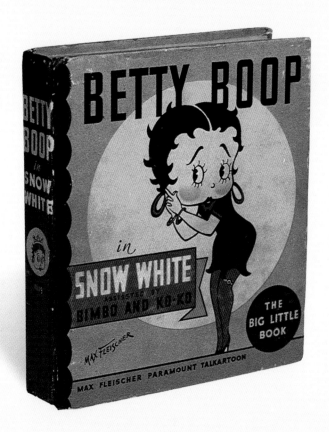

Betty Boop in Snow White, Wallace West, 1934

Funnies

Little Orphan Annie, Betty Boop, Popeye, Mickey Mouse, Bugs Bunny, Donald Duck, Little Lulu—these names from America's funny pages have become perennial favorites for readers everywhere. With jokes, pratfalls, quick wit, and a bit of homespun wisdom, these comic strips offered readers a respite from the steady flow of hard news that came through the newspapers day in and day out.

How did the "funny pages" become more than just a pop culture phenomenon? The first cartoon "picture story" was developed way back in the early 1800s. The writer and illustrator was Rodolphe Topffer, a Swiss artist who made a

crucial decision: to divide his stories into separate frames which featured an ongoing narrative that was printed underneath each individual drawing.

The style worked its way to Germany, then England, and eventually, the Americans caught on. In 1889, famed publisher Joseph Pulitzer started running a regular comic section in the Sunday edition of his *New York World.* A few years later, in 1892, a strip called *The Little Bears and Tigers* began appearing in the *San Francisco Examiner.* Drawn by James Swinnerton, the comic was a slight bit of humorous play that offered a lighthearted distraction from the news. Its historic significance lay in the fact that it was the first strip to appear regularly and be read by a large audience.

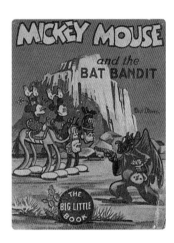

A noted breakthrough occurred on February 16, 1896, when the first color newspaper comic panel was created by Richard Outcault and published in *New York World.* It was called *The Great Dog Show in M'Googan's Avenue.* It had as its star a funny little kid printed in yellow, who became so popular that he soon reappeared the following month in a panel called *War Scare in Hogan's Alley.* The appearance of the "Yellow Kid" served as the real starting point for the cartoon "funnies" that we have come to know to this day.

Mickey Mouse and the Bat Bandit, Floyd Gottfredson, 1935

On December 12, 1897, the *Katzenjammer Kids,* drawn by Rudolph Dirks for the *American Humorist,* made its debut, and with it the art of the funnies took a giant leap forward: entire storylines were developed in sequence, with one panel following another like frames in a motion picture, and with a cast of characters that appeared and reappeared. And most importantly, Dirks experimented with his text and discovered that by enclosing his words in small "balloons" that were drawn inside the illustrated panels, his readers

would react to his humor with greater spontaneity and laughter. The use of balloons continues to be a permanent fixture of comics, nearly 100 years later.

In 1919, Captain Joseph Patterson of Chicago's *Daily News* began encouraging the development of many new comic strips for his paper. He provided fertile ground for several young writers and illustrators who created some of the best-loved comic strip characters ever made.

Patterson sought out the simplest of concepts which he felt appealed to the masses and built strips upon those concepts: *Dick Tracy* and the public's morbid fascination with crime; *Little Orphan Annie* and the lure of overpowering sentiment; *Moon Mullins* and the everlasting delight with situations that create belly-laughter.

back cover

Many BLBs grew directly out of these comic strips, including *Little Orphan Annie*.

The *Little Orphan Annie* illustrations had character dialogue bubbles drawn at the top of the frames. In the BLBs, the bubbles were removed and simple cross-hatching was drawn in the empty space where the bubbles had been. This had the effect of leaving Annie and her friends occupying just the lower portion of the frame, subtly dramatizing the fact that this little orphan girl was enveloped by a great world that was sometimes beyond her reach. That is indeed the story of Annie, who manages to navigate through the vast expanse with charm, wit, and just a little bit of cunning.

BLBs did not, and could not, ignore one of America's leading comic icons: Mickey Mouse. Almost fifty Mickey Mouse BLBs were published, and it is interesting to watch the artistic evolution of the character of Mickey grow and change over the years.

One extremely popular comic strip of the 1930s, *Alley Oop,* came from the pages of *The New York Telegram,* and four were made into BLBs. Vince Hamlin drew and wrote the books, which were set during the Neanderthal era. The cave man hero was a good-hearted, Brooklyn-accented man with a wife and a doting Stegosaurus. The later stories introduced Alley Oop time-traveling to various historic eras, with very humorous results!

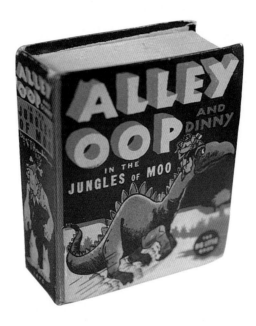

Alley Oop and Dinny in the Jungles of Moo, Vince T. Hamlin, 1938

"Snow-white Fairer Is than You."

Betty Boop in Snow White, Wallace West, 1934

Pinocchio and Jiminy Cricket,
Walt Disney Studios, 1940

22

Mickey Mouse Sails for Treasure Island,
Walt Disney Studios, 1935

Dumbo of the Circus, Only His Ears Grew,
Walt Disney Studios, 1941

Snow White and the Seven Dwarfs, Walt Disney Studios, 1938

Hairbreadth Harry in Department Q.T., J. M. Alexander, 1935

Mickey Mouse Presents
Walt Disney's Silly Symphonies Stories,
Walt Disney Studios, 1936

The Story of Skippy, Percy Crosby, 1934

Og, Son of Fire, Irving Crump, 1936

Tales of Demon Dick and Bunker Bill, Spencer, 1934
(unusual size still considered in BLB format)

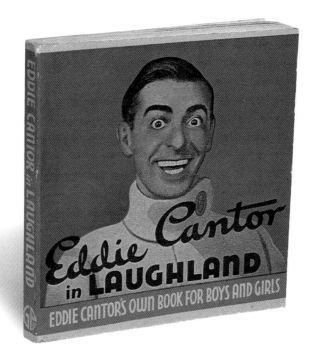

Eddie Cantor in Laughland, Harold Sherman, 1934

★ ALL PICTURES COMICS ★

MARGE'S
LITTLE LULU
ALVIN BBY

WHITMAN PUBLISHING COMPANY
Racine, Wisconsin

31

(opposite) Little Lulu, Alvin and Tubby, Marjorie H. Buell, 1947

32 *Little Orphan Annie and the Ancient Treasure of Am, Harold Gray, 1939*

1939

1935

1938

ITTLE ORPHAN ANNIE

and the

Ancient Treasure of Am

CHAPTER I

THE REFUGE

ittle Orphan Annie and
dy Warbucks, with the help
Daddy's faithful servant, the
, had just completed their es-
e from Boris Sirob's gang of
rnational thieves, who had
gns on Daddy's ten-billion-
ar fortune in gems. They had

5

1933

1933

1941

1935

1939

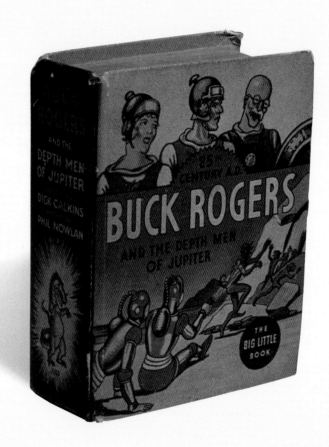

Buck Rogers and the Depth Men of Jupiter, Phil Nowlan, 1935

CHAPTER II

Space

Nothing ignites the imagination like outer space. Lying on their backs in the fresh grass of a cool evening, staring into the nighttime sky, children everywhere have looked up at the heavens and wondered what it is like out there. The Big Little Books included two archetypal space-adventure characters, Buck Rogers and Flash Gordon, that embody feelings that have stayed with us well beyond childhood.

The *Buck Rogers* series succeeded in capturing much of the realism and imagination of the new scientific age that had burst upon the American scene during the 1930s. One 1939 volume even contained a storyline about an atomic bomb, six

years before Hiroshima! Buck was a space adventurer who traveled around the solar system performing his adventures on different planets in a great art-deco spaceship and sleek space-equipment. Even the aliens and robots he fought were art deco-designed and are classics to this day.

Buck Rogers's counterpart was Flash Gordon, whose stories revolved around the blond-haired hero and his dark-haired girlfriend, Dale Arden, who together pursued a lively courtship on the distant planet of Mongo.

These two characters and their story-lines are still with us. We can see Buck Rogers in Star Trek; both serious attempts

Buck Rogers and the Doom Comet,
Phil Nowlan, 1935

at science fiction, weaving the realism of technology together with the lure of space exploration. We can also see Flash Gordon in *Star Wars*, as Han Solo and his band of rebels do battle against the evil Darth Vader.

The illustrations for these stories were made by artists who tried to give us a glimpse into the future, and they did. Their space vehicles and inventive space suits were rooted in reality and a basic understanding of aerodynamics. To many observers, the drawings even appear to subconsciously have influenced the look of the space program of the 1960s and beyond.

In an intriguing twist of art and real life, just as the NASA engineers took the name *Enterprise* from a television show and gave it to one of their space shuttles, the designers of everything from the rocket that propelled John Glenn into space to the lander that took Neil Armstrong to the moon might have drawn upon the futuristic, art deco renderings found in the BLB space series.

Flash Gordon and the
Power Men of Mongo,
Alex Raymond, 1943

Flash Gordon and the
Monsters of Mongo,
Alex Raymond, 1935

Flash Gordon and the
Monsters of Mongo
(back cover)

Flash Gordon and the Red Sword
Invaders, Alex Raymond, 1945

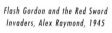

Flash Gordon and the
Tournaments of Mongo,
Alex Raymond, 1935

Flash Gordon and the
Tournaments of Mongo
(back cover)

Flash Gordon and the
Tyrant of Mongo,
Alex Raymond, 1941

DR. HUER'S YELL IN WILMA'S EARPHONES ALMOST DEAFENED HER: "NO! NO! ON YOUR LIFE— DON'T DO THAT!" HE CRIED.

18 FLASH GORDON

cruel Ming.

At that moment, the emperor Ming was carrying on his plan of making Dale as miserable as possible.

"I have great plans for you," he said, "when I no longer need you to bait my trap for Flash Gordon."

"I'm not afraid of what happens to me," Dale answered defiantly, "as long as Flash is free." She knew that Flash must be

Ming Spoke to Dale

Flash Gordon and the Power Men of Mongo, Alex Raymond, 1943

Buck Rogers and the Depth Men of Jupiter, Phil Nowlan, 1935
Buck Rogers: 25th Century A.D., Phil Nowlan, 1933
Buck Rogers and the Planetoid Plot, Phil Nowlan, 1936

Buck Rogers and the Doom Comet, Phil Nowlan, 1935
Buck Rogers in the City Below the Sea, Phil Nowlan, 1934

Buck Rogers: 25th Century A.D.,
Phil Nowlan, 1933

Buck Rogers in the City Below the Sea,
Phil Nowlan, 1934

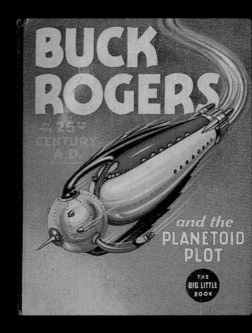

Buck Rogers and the Planetoid Plot, Phil Nowlan, 1936

Terry and the Pirates, Shipwrecked on a Desert Island, Milton Caniff, 1938

Adventure

In the 1930s, whether you were a twelve-year-old huddled in a small farmhouse amid sprawling Iowa cornfields on a cold night or peering out of a sixth-floor tenement window in Brooklyn looking down at glistening rain-soaked streets and blinking stoplights, you yearned to discover a life beyond the horizon–and a dime could buy you that. With a BLB adventure, you could go to another world filled with exotic locations, outrageous heroes and heroines, and wonderfully scary dangers. The American ethic triumphed, the bad guys lost, morality was preserved.

This pull on the imagination is the stuff of youngsters to this day, which is why the BLB

adventure series was one of the most popular genres throughout the 1930s and 1940s. Every book was rife with cliffhangers, chapters that would compel readers on to the next, leaving them wondering how their hero would escape the latest calamity. In the groundbreaking series *Terry and the Pirates,* our young hero was left a map of a secret, abandoned gold mine in China by his grandfather. In these books, Terry and his friend Pat Ryan, a handsome, curly-haired, two-fisted adventurer, travel around Asia, moving from one fast-paced thriller to another.

Rather than relying solely on danger to keep his stories alive, the creator and illustrator, Milton Caniff, developed an array of fascinating characterizations, each drawn with such intricate graphic detail that the exotic settings conveyed an unprecedented authenticity.

Caniff meticulously researched his subject, yet his graphic technique was simple: in his drawings, as in nature, objects and people are made up of shapes, not lines. Every object casts a shadow and has different degrees of light and dark which distinguishes the different objects and their textures. Even in a simple rendering of a boat, Caniff used this innovative technique.

Women illustrators were extremely rare at the time, and even rarer in BLBs. Dahlia Messick is the only woman who ever wrote and illustrated a BLB series. Her book, *Brenda Starr and the Masked Impostor,* is a wonderful memorial to a woman artist who succeeded in breaking through the sexist barriers of her day. In the beginning of her career she changed her professional name from Dahlia to Dale to increase her chances of selling her work. She felt that the name *Dale* would mislead editors as to her real gender and hoped that, as a result, they would not discriminate against her work.

Only three other female illustrators can be found in BLBs: Martha Orr drew *Apple Mary,* Juanita Bennet illustrated *Treasure Island,* and Marjorie Buell did the drawings for *Little Lulu.*

Another woman of note to participate in BLBs was Margaret Sutton, who authored the famous *Judy Bolton* books. She wrote the *Kay Darcy* book but published under the pen name of Irene Ray.

"The Japs Had—Oh, I Can't—"

Terry and the Pirates, War in the Jungle, Marla Berke, 1946

TARZAN ESCAPES

THE
BIG LITTLE
BOOK

METRO-GOLDWYN-MAYER PICTU

READ THE BOOK • SEE THE PICTU

Tarzan, adapted from Edgar Rice Burroughs

1942

1948

1940

1950

1945

1938

1949

1939

George S. Elrick
1967

*(opposite) Tarzan Escapes starring Johnny Weissmuller,
created by Edgar Rice Burroughs, 1936*

50

(above and right)
Wash Tubbs in Pandemonia,
Roy Crane, 1934

romanth and adventure. But al:
You found romanth in thith
cathle, while I wath more mither
than ever."

Prince Willy Nilly has come to
conclusion that the big wide worl
not such a kind old soul when a yo
man is all alone.

"Well," returns Wash, "it
goes to prove, Your Highness,
romance is everywhere. If yo
blind, you can circle th' globe
never find it. Open your eyes, tho
an', by golly, you'll see it settin

"Romance Is Everywhere."

Wash Tubbs and Captain Easy,
Hunting for Whales, Roy Crane, 1938

CHAPTER I

I CHOOSE A LIFE OF ADVENTURE

(below and opposite)
Robinson Crusoe, adapted from Daniel Defoe, 1934

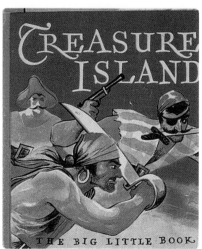

Treasure Island, adapted from Robert Louis Stevenson, 1933

The Return of the Phantom, Lee Falk, 1942
The Green Hornet Strikes!, adapted from Fran Striker, 1940

Black Silver and his Pirate Crew with Tom Trojan, 1937

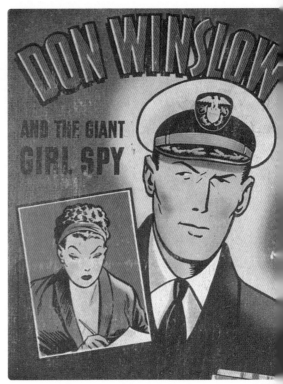

Mac of the Marines in Africa, Mark Smith, 1936

Don Winslow and the Giant Girl Spy, Lt. Frank V. Martinek, 1946

Don Winslow, U.S.N., Lieutenant Commander,
Lt. Commander Frank V. Martinek U.S.N.R., 1935

Captain Easy Behind Enemy Lines, Roy Crane, 1943

58

The Little Colonel starring Shirley Temple (Twentieth Century Fox), Anne Fellows Johnston, 1935

CHAPTER IV

Movies

For the generation that grew up in the 1930s and 1940s, the movie industry was everywhere. If you lived in Los Angeles, the company town, your backyard could easily face a studio backlot. If you lived in small-town America, the movie "palace" was at the center, with its bright lights blazing and beckoning you to come inside the darkened theater. Soon the curtain would open, a flicker of light would jump onto the white screen, and you'd find yourself transported to another life.

For many, the BLB was another experience of what the movies could offer, a "cinematic" telling of stories lifted from the box office hits of the day. The movie BLBs were a boon to Hollywood's

Union Pacific starring Barbara Stanwyck,
RKO Pictures, Eleanor Packer, 1939

60

Lions and Tigers starring Clyde Beatty, Universal Pictures, 1934

Alice in Wonderland starring Charlotte Henry, Paramount Pictures,
adapted from Louis Carroll, 1934

Our Gang: For Pete's Sake,
Charles T. Clinton, 1934

major studios, providing them with an unparalleled opportunity to promote their films.

Before films made Tarzan's call through the wilds recognizable to moviegoers everywhere, many readers first entered jungle life through the highly successful newspaper series of *Tarzan*. The appeal of *Tarzan* was very basic and compelling, the classic story of a man fighting the elements of the modern world and winning. It was only natural that *Tarzan* was turned into one of BLB's largest series, reaching 24 books, with three of them based on films—one featuring Buster Crabbe and two starring Johnny Weismuller.

Whitman, Lynn, Saalfield, and Engel-van Wiseman all produced books from movie titles and they have a slightly larger format of 5" x 5¾" x ⅞".

True to the spirit that gave life to the movies, these books contained photos from the actual films instead of hand-drawn illustrations. They captured what the readers would see on screen: a muscular Johnny Weismuller as Tarzan, jumping from vine to vine to land on an elephant and lead the herd on a mission of rescue; a stoic Gary Cooper riding tall in *The Plainsman*, taming the Wild West; or the wisecracking W. C. Fields delivering smiles in the classic *David Copperfield*.

A particularly unique aspect of these books is that the photos from these films are rather rare since many of them do not appear anywhere else.

For readers today, the movie BLBs help jog our memories and take us back to a time that held the roots of modern American cinema: the elegant settings, lush costumes, fast-paced action, and panoramic scenery that enveloped audiences.

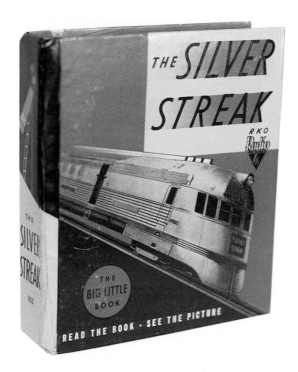

The Silver Streak starring Charles Starrett (RKO Pictures), 1935

64

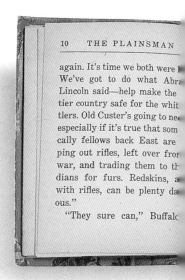

10 THE PLAINSMAN

again. It's time we both were ▊
We've got to do what Abra▊
Lincoln said—help make the ▊
tier country safe for the whit▊
tlers. Old Custer's going to ne◂
especially if it's true that som▊
cally fellows back East are ▊
ping out rifles, left over fron▊
war, and trading them to th▊
dians for furs. Redskins, a▊
with rifles, can be plenty da▊
ous."

"They sure can," Buffal◂

The Plainsman starring Gary Cooper and Jean Arthur (Paramount Pictures), adapted by Eleanor Packer, 1936

"dskins Armed With Rifles Are Dangerous."

Kit Carson and The Mystery Riders
starring Johnny Mack Brown and Noah Beery (Mascot Pictures),
Charles T. Clinton, 1935

Terror Trail starring Tom Mix
(Universal Pictures), 1934

Call of the Wild starring Clark Gable and Loretta Young (Twentieth Century Fox), adapted by Rex Carlson, 1935

The Story of Johnny Weissmuller, The Tarzan of the Screen (MGM Pictures), 1934

Burn 'em up Barnes starring Jack Mulhall and Frankie Darrrow (Mascot Pictures), John Rathmell and Colbert Clark, 1935

West Point of the Air starring Robert Young and Wallace Beery (MGM Pictures), 1935

Men with Wings starring Fred MacMurray (Paramount Pictures), Eleanor Packer, 1938

Les Miserables starring Fredrick March and Charles Laughton (Twentieth Century Fox), adapted by Lewis Graham, 1935

Little Women starring Katherine Hepburn (RKO Pictures), adapted from Louisa May Alcott, 1934

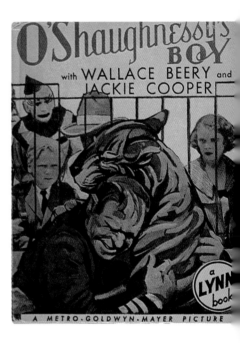

O'Shaughnessy's Boy starring Wallace Beery and Jackie Cooper (MGM Pictures), adapted by Lebbeus Mitchell, 1935

Gangster's Boy starring Jackie Cooper (Monogram Pictures), Karl Brown and Robert Andrews, 1939

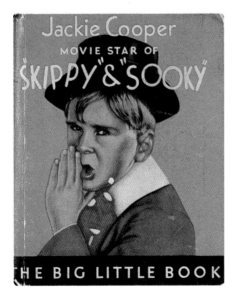

Jackie Cooper Movie Star of "Skippy" and "Sooky," Eleanor Packer, 1933

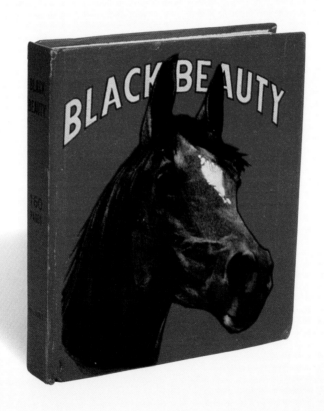

Black Beauty, adapted from Anna Sewell and Althea L. Clinton, 1934

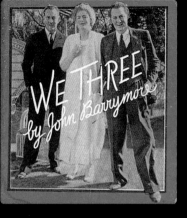

We Three (MGM Pictures), John Barrymore, 1935

It Happened One Night starring Clark Gable and Claudette Colbert (Columbia Pictures), adapted by Robert Riskin, 1935

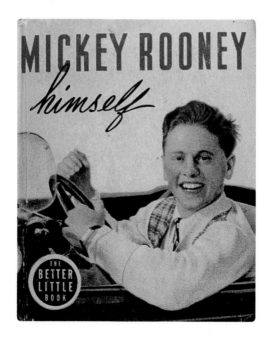

Mickey Rooney Himself (MGM Pictures), Eleanor Packer, 1939

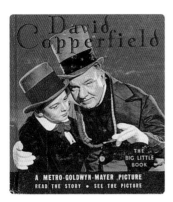

David Copperfield starring Freddie
Bartholomew and W.C. Fields (MGM Pictures),
adapted from Charles Dickens, 1934

The Three Musketeers starring Walter Able
(RKO Pictures), 1935

(above and left) Little Lord Fauntleroy starring Freddie Bartholomew (United Artist Pictures), 1936

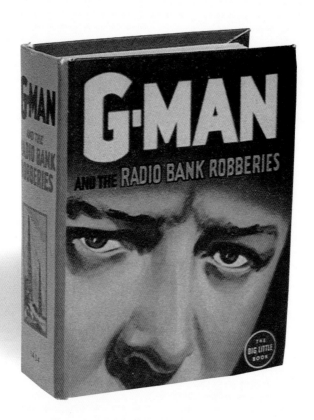

G-Man and the Radio Bank Robberies, Allen Dale, 1937

CHAPTER V

Crime

In the 1920s and 1930s, on nearly every morning, almost every day, on street corners of every major American city, the cries of young paperboys blared out the tabloid's latest scandals: "Read all about it, read all about it! Mayor charged with racketeering! Mobster slain in local restaurant! Capone kills 7 in Saint Valentine's Day Massacre!"

Prohibition was the law, illegal gambling was in, and organized crime was part of the American mystique. What better characters to do battle with these nefarious and subversive forces than all-American crime busters like Dick Tracy, Charlie Chan, Ellery Queen, Mandrake the Magician, Red Berry, and Dan Dunn.

Dick Tracy's creator, Chester Gould, lived in Chicago, the hub of America's crime world, where shoot-outs and graft were watchwords of the day. Gould's drawing style is wonderful and simple. Everything is rendered in high contrast, with backgrounds almost abstract in their simple black-and-white designs. There are no ambiguities in Gould's work, in either design or character. Things were indeed black and white, good or bad, just like Americans wanted them to be. We still do.

Dick Tracy's BLB stories were taken right from the daily strips and were about a hard-nosed pistol-packing charmer, fighting battles against a roster of colorful foes including No Face, Mrs. Prune Face, Fly Face, and Rhodent.

Dashiell Hammett, one of America's quintessential crimewriters and creator of such memorable works as *The Maltese Falcon* and *The Third Man,* wrote a popular comic strip crime series titled *Secret Agent X-9* under the pen-name Charles Flanders, which was turned into a BLB

book. William Randolph Hearst commissioned the crime strip, insisting that it contain "a hero who will combine the toughness of a detective like Tracy with the mystery of a secret operative like Dan Dunn." This was a tall order, and Hearst thought it could only be delivered by a writer with the gifts of a Dashiell Hammett.

Although Hammett was at the height of his popularity, he took the assignment strictly for the money, for it seemed that his lifestyle had already outpaced his book income. Hearst embarked on an exhaustive search for an artist whom he could team Hammett up with, finally settling on Alex Raymond. On January 29, 1934, *Secret Agent X-9* hit the newspapers, and in just a few short years the BLB followed, appearing in 1936.

Dick Tracy, Chester Gould

DICK
TRACY
ENCOUNTERS FACEY

39¢

Dick Tracy and the Boris Arson Gang, Chester Gould, 1935

Dick Tracy in Chains of Crime, Chester Gould, 1936

Dick Tracy and the Man with No Face,
1938

83

The Adventures of Dick Tracy, Detective, Chester Gould, 1934

Dick Tracy, Detective and Federal Agent,
Chester Gould, 1936

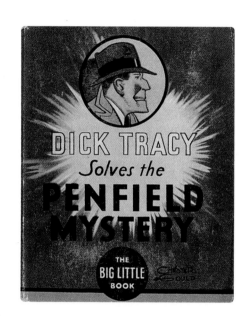

Dick Tracy Solves the Penfield Mystery, Chester Gould, 1934

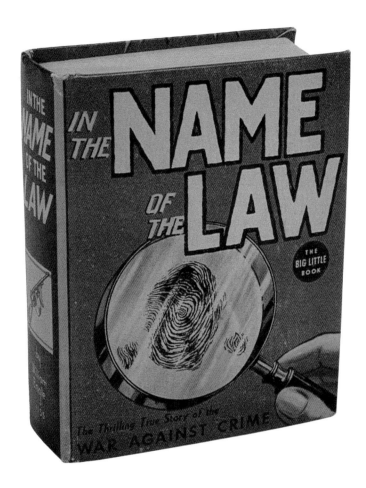

In the Name of the Law, William Engle, 1937

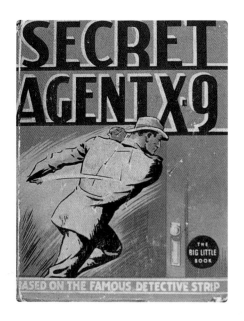

Secret Agent X-9, Charles Flanders
(Dashiell Hammett), 1936

Radio Patrol, Charlie Schmidt, 1935

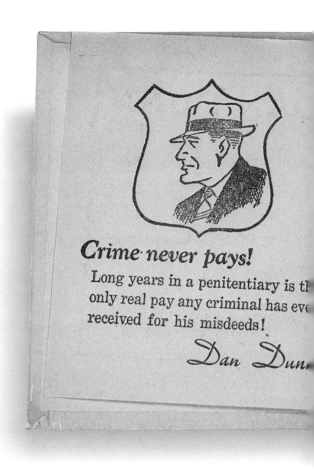

Crime never pays!

Long years in a penitentiary is the only real pay any criminal has ever received for his misdeeds!

Dan Dun

(right) Dan Dunn, Secret Operative 48, Norman Marsh, 1934

DAN DUNN

SECRET OPERATIVE 48

On the Trail of Wu Fang

By Norman Marsh

Based on the Famous Newspaper Strip

WHITMAN PUBLISHING CO.
RACINE, WISCONSIN

(above, right center and bottom)
Dan Dunn, Secret Operative 48 on the Trail of Wu Fang,
Norman Marsh, 1938

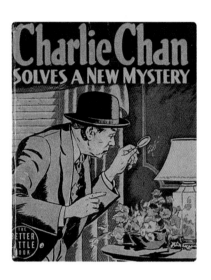

Charlie Chan Solves a New Mystery,
adapted from Earl Derr Biggers, 1940

Mandrake the Magician, Mighty Solver of Mysteries,
Lee Falk, 1942

G-Man on the Crime Trail, Lou Hanlon, 1936

G-Man vs. The Fifth Column, Edwin C. Johnson, 1941

Gang Busters Step In, adapted from the Phillip H. Lord radio program by Isaac McAnally, 1939

Pesky Asked Brenda to Lunch

Brenda Starr and the Masked Impostor, Dale Messick, 1943

The Lone Ranger and the Black Shirt Highwayman, adapted from Fran Striker, 1939

CHAPTER VI

Wild West

Can you imagine that someday there might be a generation of Americans who can't remember playing cowboys and Indians in their backyards, their cap pistols strapped to their belts and their bows and feathered arrows at their sides? Well, it hasn't happened yet. Even in the age of *Star Wars* and *The Terminator*, the old-fashioned Western still has its appeal. What is more American than riding alone into a one-horse town to save the poor locals from a marauding gang of bad guys, shooting them up all in the name of justice, and then riding off into the sunset leaving everyone with the question, "Just who

was that guy?" You can laugh at
Westerns, but they are very hard to
laugh off in the historical context of
American storytelling.

The flavor of the raw, untamed
West, with the self-sacrificing hero at
its center, is fully captured in the BLB
Western series. If BLBs were still being
published today, certainly Clint
Eastwood, the quintessential American
Western hero, and his portrayal in the
Oscar-winning film *The Unforgiven*,
would stand out as the cornerstone of
the series. In the 1930s, though, it was
Tom Mix who embodied the classic cow-
boy hero and who fought scoundrels,
drifters, killers, and rustlers. He was a

roaming, free-spirited soul who ventured through the badlands of the open frontier, tracked down the lawless, hooked up with posses and other men and women of goodwill, and hoped to bring decency and honor to brave settlers intent on building a new life at the edges of America.

Other characters from BLBs—Buck Jones, Ken Maynard, King of the Royal Mounted—bring us to the core and epitomize the Western tale. An innocent woman done wrong saved by a stranger who has wandered into town at just the right time. There's a sheriff, a posse, a gang of rustlers, cattle by the hundreds, and several long kisses. They all had the traits we associate with our idols.

He Was Hardly More Than a Boy

There's also *The Lone Ranger*, one of the few series that didn't derive its start from comics but instead came out of the successful radio show. King Features bought the adaptation rights to *The Lone Ranger* in 1938, and later it made its debut in comics to become one of the longest running westerns in comic history. Both Dell and Whitman turned it into popular BLBs.

BLBs couldn't ignore two other major cowboy stars of radio, cinema, and comics: Gene Autry and Roy Rogers. The two men vied for the honor of being America's top film cowboy. In the long run, Roy won out, appearing in almost eighty films and ten BLBs.

Also of interest is one BLB called *Flame Boy and the Indians' Secret*, which was a western illustrated by an American Hopi Indian—Sekakuku.

Tom Mix and the Stranger from
the South, Peter Daryll, 1936

Tom Mix in the Range War,
Buck Wilson, 1937

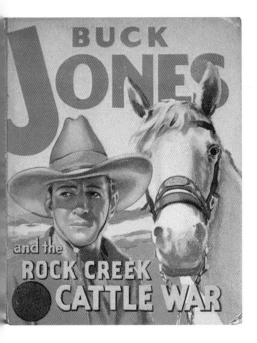

Buck Jones and the Rock Creek Cattle War,
Gaylord Dubois, 1938

Tim Tyler's Luck and the Plot of the Exiled King,
Lyman Young, 1939

King of the Royal Mounted, adapted from Zane Grey, 1936

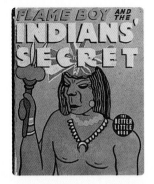

(right) Flame Boy and the Indians'
Secret, Goren Arnold, 1938

(middle) Men of the Mounted,
Ted McCall, 1934

(above) Chester Gump at Silver Creek
Ranch, Sidney Smith, 1933

(above) Kazan in Revenge of
the North, adapted from
James Oliver Curwood, 1937

(above) George O'Brien and the Hooded
Riders, Gaylord DuBois, 1940

*Bobby Benson on the H-Bar-O Ranch,
Peter Dixon, 1934*

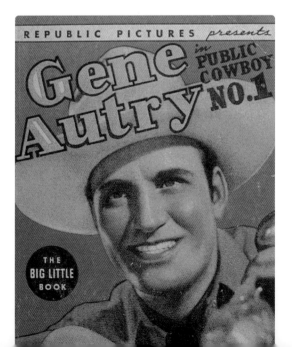

*Gene Autry in Public Cowboy No. 1,
adapted by Eleanor Packer, 1938*

Smilin' Jack and the Stratosphere Ascent, Zack Mosley, 1937

Aviation

Man had been anchored to the earth by gravity since he first stood on two feet. But eventually, in the beginning of the century, he was free to roam the skies, and airplanes became the vehicles that would transport people to exotic places, romance, danger, and fun.

Tailspin Tommy, Barney Baxter, Smilin' Jack, Captain Frank Hawks—these were some of the comic characters who would embark on a series of fast-paced adventures built around aircraft.

Tailspin Tommy, originally written by Glenn Chaffin and illustrated by Hal Forrest, appeared in 1928 on the heels of the Charles Lindbergh rage that followed the daring aviator's solo flight

across the Atlantic. The character made it into the BLB format by 1933, written and illustrated by Hal Forrest, and the books were a favorite of the BLB airman series.

One title, *Tailspin Tommy: The Dirigible Flight to the North Pole,* features Forrest's extremely well-written adventure along with his exquisitely drawn realistic graphics. It shows how "Tailspin" Tommy Tomkins "was as much at home in an airplane as most men are in the suit of clothes they wear every day," and it takes the reader on an unconventional great adventure to the North Pole that combines biplanes and dirigibles.

Another early strip, *Skyroads,* was created by Lt. Lester Maitland, a pilot who made the first flight from California to Hawaii in June, 1927. The first *Skyroads* BLB tells the story of Hurricane Hawk's battle with Black Vulture, and the next BLB follows the adventures of Clipper Williams and his band, known as the *Flying Region.*

As the *Skyroads* series progressed, Zack Mosely, a technically superb artist, was brought onto the project. In 1933, Mosely went on to write and draw his own series, *Smilin' Jack,* which featured beautifully rendered aircraft that contained high quality technical detail along with zany plots, wild cliffhangers, sexy women, and daredevil antics.

Mosely's aircraft drawings were technically brilliant, extremely accurate, and well-drawn, but his character renderings, their perspective, and lack of design take away from the books' overall artistic quality.

Tailspin Tommy and the Sky Bandits, Hal Forrest, 1938
Tailspin Tommy and the Island in the Sky, Hal Forrest, 1936

Tailspin Tommy: The Dirigible Flight to the North Pole, Hal Forrest, 1934



"Tailspin Tommy and the Hooded Flyer, Hal Forrest, 1937"

Bottom caption: "Tailspin Tommy: Hunting for Pirate Gold, Hal Forrest, 1935"

*Tailspin Tommy and the Hooded Flyer, Hal Forrest, 1937*



Tailspin Tommy: Hunting for Pirate Gold, Hal Forrest, 1935

(left) Smilin' Jack and the Coral Princess, Zack Mosley, 1945
(right) Smilin' Jack and the Stratosphere Ascent (back cover), Zack Mosley, 1937

Barney Baxter in the Air with the Eagle Squadron, Frank Miller, 1938

Captain Frank Hawks, Air Ace and the League of Twelve,
Irwin Myers, 1938

"Heave To! Who Are You?"

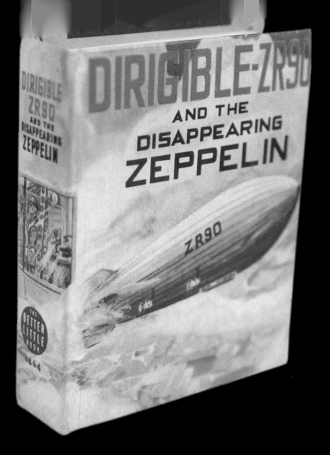

The Adventures of Dick Tracy, Detective, 83

Alice in Wonderland starring Charlotte Henry, 60

Alley Oop and Dinny in the Jungles of Moo, 20

Barney Baxter in the Air with the Eagle
 Squadron, 112, 113

Betty Boop in Snow White, 16, 21

Billy the Kid, 102

Black Beauty, 71

Black Silver and His Pirate Crew with
 Tom Trojan, 55

Bobby Benson on the H-Bar-O Ranch, 105

Brenda Starr and the Masked Impostor, 94

Buck Jones and the Rock Creek Cattle War, 100

Buck Jones and the Two-Gun Kid, 101

Buck Rogers in the City Below the Sea, 42, 43

Buck Rogers and the Depth Men of Jupiter, 34, 42

Buck Rogers and the Doom Comet, 36, 37, 42

Buck Rogers and the Planetoid Plot, 42, 43

Buck Rogers in the 25th Century A.D., 42, 43

Bugs Bunny, 31

Burn 'Em Up Barnes, 67

Captain Easy Behind Enemy Lines, 57

Captain Frank Hawks, Air Ace and the League
 of Twelve, 114

Captain Robb of Dirigible ZR-90 and the
 Disappearing Zeppelin, 115

Call of the Wild, 66

Charlie Chan Solves a New Mystery, 90

Chester Gump at Silver Creek Ranch, 104

Dan Dunn, Secret Operative 48, 89

Dan Dunn, Secret Operative 48 on the Trail of
 Wu Fang, 88–89, 89

David Copperfield starring Freddie Bartholemew
 and W.C. Fields, 74

Dick Tracy and the Boris Arson Gang, 82

Dick Tracy and the Man with No Face, 83

Dick Tracy and the Spider Gang, 80

Dick Tracy and the Wreath Kidnapping Case, 80

Dick Tracy, Detective and Federal Agent, 83

Dick Tracy Encounters Facey, 81

Dick Tracy from Colorado to Nova Scotia, 80

Dick Tracy in Chains of Crime, 82

Dick Tracy on the High Seas, 80

Dick Tracy Solves the Penfield Mystery, 85

Dick Tracy, Special F.B.I. Operative, 80

Don Winslow and the Giant Girl Spy , 56

Don Winslow, U.S.N., Lieutenant Commander, 57

Dumbo of the Circus, Only His Ears Grew, 22

Eddie Cantor in Laugh Land, 29

Ellery Queen: The Adventure of the Last
 Man Club, 91

Flame Boy and the Indians' Secret, 104

Flash Gordon and the Monsters of Mongo, 39

Flash Gordon and the Power Men of Mongo, 39, 41

Flash Gordon and the Red Sword Invaders, 39

Flash Gordon and the Tournaments of Mongo, 39

Flash Gordon and the Tyrant of Mongo, 39

Flash Gordon on the Planet Mongo, 10, 40

G-Man and the Radio Bank Robberies, 76

G-Man on the Crime Trail, 92

G-Man vs. The Fifth Column, 93

The Green Hornet Strikes!, 54

Gang Busters and Guns of Law, 93

Gang Busters Step In, 93

Gangster's Boy starring Jackie Cooper, 70

Gene Autry in Public Cowboy No. 1, 105

George O'Brien and the Hooded Riders, 104

Hairbreadth Harry in Department Q.T., 25

In the Name of the Law, 86

Inspector Wade of Scotland Yard, 88

Inspector Wade Solves the Mystery of the
 Red Aces, 88

It Happened One Night starring Clark Gable
 and Claudette Colbert, 72

Jackie Cooper Movie Star of "Skippy"
 and "Sooky," 70

Jungle Jim and the Vampire Woman, 55

Kazan in Revenge of the North, 104

King of the Royal Mounted, 103

Kit Carson and the Mystery Riders, 65

Les Miserables starring Fredrick March &
 Charles Laughton, 68

Lions and Tigers starring Clyde Beatty, 60

The Little Colonel starring Shirley Temple, 58

Little Lord Fauntleroy, 74, 75

Little Lulu, Alvin and Tubby, 30

Little Orphan Annie and Chizzler, 33

Little Orphan Annie and Punjab the Wizard, 33

Little Orphan Annie and Sandy, 33

Little Orphan Annie and the Ancient Treasure
 of Am, 32, 33

Little Orphan Annie and the Ghost Gang, 33

Little Orphan Annie and the Haunted Mansion, 33

Little Orphan Annie and the Mysterious
 Shoemaker, 33

Little Women starring Katherine Hepburn, 69

The Lone Ranger and the Black Shirt
 Highwayman, 96

Mac of the Marines in Africa, 56

Mandrake the Magician Mighty Solver
 of Mysteries, 90

Men of the Mounted, 104

Men with Wings starring Fred MacMurray, 67

Mickey Mouse and the Bat Bandit, 18, 19

Mickey Mouse Presents Walt Disney's Silly
 Symphonies Stories, 26

Mickey Mouse Sails for Treasure Island, 22

Mickey Rooney Himself, 73

Og, Son of Fire, 27

O'Shaughnessy's Boy starring Wallace Beery
 and Jackie Cooper, 70

Our Gang: For Pete's Sake, 60

Pinnochio and Jiminy Cricket, 22

The Plainsman starring Gary Cooper and
 Jean Arthur, 64

Radio Patrol, 87

Red Barry, Ace Detective, Hero of the Hour, 95

Red Barry, Undercover Man, 95

The Return of the Phantom, 54

Robinson Crusoe, 53

Secret Agent X-9, 87

The Silver Streak starring Charles Starrett, 62, 63

Smilin' Jack and the Coral Princess, 111

Smilin' Jack and the Stratosphere Ascent, 106, 111

Snow White and the Seven Dwarfs, 23

The Son of Tarzan, 49

The Story of Johnny Weissmuller, The Tarzan
 of the Screen, 67

The Story of Skippy, 27

Tailspin Tommy: The Dirigible Flight to the
 North Pole, 109

Tailspin Tommy and the Hooded Flyer, 110

Tailspin Tommy and the Island in the Sky, 108

Tailspin Tommy and the Sky Bandits, 108

Tailspin Tommy, Hunting for Pirate Gold, 110

The Tales of Demon Dick and Bunker Bill, 28

Tarzan and the Ant Men, 49

Tarzan and the Jewels of Opar, 49

Tarzan and the Journey of Terror, 49

Tarzan and the Lost Empire, 49

Tarzan and the Tarzan Twins in the Jungle, 49

Tarzan Escapes starring Johnny Weissmuller, 48

Tarzan in the Land of the Giant Apes, 49

Tarzan, the Mark of the Red Hyena, 49

Tarzan the Terrible, 49

Terror Trail starring Tom Mix, 65

Terry and the Pirates and War in the Jungle, 47

Terry and the Pirates, Shipwrecked on a
 Desert Island, 44

This Is the Life starring Jane Withers, 74

Tim Tyler's Luck and the Plot of the Exiled
 King, 100, 101

Tom Mix and the Stranger from the
 South, 100, 101

Tom Mix in the Range War, 100, 101

The Three Musketeers starring Walter Able, 74

Treasure Island, 52, 53

Union Pacific starring Barbara Stanwyck, 60

Wash Tubbs and Captain Easy, Hunting for
 Whales, 51

Wash Tubbs in Pandemonia, 50

We Three, 72

West Point of the Air starring Robert Young
 and Wallace Beery, 67

The Adventures of Dick Tracy, 12, 13
Alley Oop, 20
American Humorist, 18
Apple Mary, 46
Autry, Gene, 99
Armstrong, Neil, 38
Barney Baxter, 107
Bennet, Juanita, 46
Betty Boop, 17
Black Vulture, 108
Brenda Starr, 46
Buck Jones, 99
Buck Rogers, 10, 35–37
Buell, Marjorie, 46
Bugs Bunny, 17
Caniff, Milton, 46
Cantor, Eddie, 13
Captain Frank Hawks, 107
Chaffin, Glenn, 107
Charlie Chan, 77
Colbert, Claudette, 13
Cooper, Gary, 61
Crabbe, Buster, 61
The Cure, 9
da Vinci, Leonardo, 14
Daily News (Chicago), 19
Dan Dunn, 77, 79
David Copperfield, 61
Dell Publishing Company, 13, 99
Dick Tracy, 19, 77, 78, 79
Dirks, Rudolph, 18–19
Donald Duck, 17
Eastwood, Clint, 98
Ellery Queen, 77
Enterprise (NASA), 38
Fast Action Series, 13
Fields, W.C., 61
Flame Boy, 99
Flanders, Charles, 78

Flash Gordon, 10, 13, 14, 35, 36–38
Flying Region, 108
Forrest, Hal, 107, 108
Gable, Clark, 13
Glenn, John, 38
Goldsmith Publishing Company, 13
Gould, Chester, 78
The Great Dog Show in M'Googan's Avenue, 18
Hamlin, Vince, 20
Hammett, Dashiell (Charles Flanders), 78, 79
Hearst, William Randolph, 79
Hurricane Hawk, 108
Indians' Secret, 99
It Happened One Night, 13
Judy Bolton Books, 46
Katzenjammer Kids, 18
Kay Darcy Book, 46
Lindbergh, Charles, 107
The Little Bears and Tigers, 18
The Little Colonel, 13
Little Lulu, 17, 46
Little Orphan Annie, 17, 19
The Lone Ranger, 98
Lynn Publishing, 46
Maitland, Lt. Lester, 108
The Maltese Falcon, 78
Mandrake the Magician, 77
Masked Impostor, 46
Messick, Dahlia (Dale), 46
Mickey Mouse, 17, 19
Mosely, Zach, 108
The New York Telegram, 20
New York World, 18
Orr, Martha, 46
Our Gang, 13
Outcault, Richard, 18

Patterson, Captain Joseph, 19
Pearl, Jack, 13
The Plainsman, 61
Popeye, 13, 17
Pulitzer, Joseph, 18
Radio Star Series, 13
Ray, Irene, 46
Raymond, Alex, 79
Red Berry, 77
Roach, Hal, 13
Rogers, Roy, 99
Saalfield Publishing, 46
San Francisco Examiner, 18
Secret Agent X-9, 78–79
Sekakuku, 99
Skyroads, 108
Smilin' Jack, 107, 108
Star Trek, 36–38
Star Wars, 38, 97
Sutton, Margaret (Irene Ray), 46
Swinnerton, James, 18
Tailspin Tommy, 107, 108
Tarzan, 10, 46, 61
Temple, Shirley, 13
The Terminator, 97
Terry and the Pirates, 46
The Third Man, 78
Tom Mix, 10, 98–99
Topffer, Rodolphe, 17–18
Treasure Island, 46
The Unforgivin, 98
War Scare in Hogan's Alley, 18
Weissmuller, Johnny, 61
Whitman Publishing 12, 13, 14, 46, 99
Williams, Clipper, 108
Wiseman, Engel-van, 46
World Syndicate Publishing Company, 13

BILL BORDEN is an artist and film producer whose credits include *A Midnight Clear*, *Get on the Bus*, *La Bamba*, and *Desperado*. His extensive collection of more than five hundred *Big Little Books* includes many of the rarest and most coveted editions.

STEVE POSNER is the creator of the educational news magazine *Fast Times* and host of a monthly radio show called *Night Talk* on KCEO radio in San Diego. A former television writer, his previous books include *In Front of the Camera* and *Israel Undercover*.

THE
BIG BOOK
OF
BIG LITTLE
BOOKS

Airplanes! — Pirates! — Superscience!

Mysteries! — Thrills! — Adventures:

Fun! — Comedy! — Laughs!

Detectives! — Police! — G-Men!

planes," Mac added. "But right now we've got a job to finish!".

By sundown the job was finished. That night refugees of stricken Saung were sleeping soundly below deck on the gunboat as it cruised down the Yangtze to Shanghai.

Mac of the Marines had successfully completed another dangerous assignment!

heard the violent knocking. "Some day this dray is gonna fold up right under me."

But he kept right on going and Pinky continued to knock harder and harder in a desperate effort to slow the cab down so that he and Irish could descend.

"The darn things haunted," moaned the cab driver at last as he pulled to a stop. "I better look."

That was all the opportunity

CHAPTER XXVI

th Comes to Hank Steele

is a terrified Stooge, who, later,
ls from under the pier.
've given Patton the slip. He
ks he shot me, and that I drowned.
y I knew that trick dive.
t's a good thing I didn't go on
boat with Sis. They've got a
there, and I'd have been in
before evening."

e makes his way cautiously, his

Stories of Exciting Adventures in the
BIG LITTLE BOOKS

Flying the Sky Clipper Over the Pacific
The Texas Ranger
Sombrero Pete
Tailspin Tommy in the Great Air Mystery
Tarzan Escapes
Buck Rogers and the Doom Comet
Ace Drummond, Air Hero (Capt. Rickenbacker)
Powder Smoke Range
Mandrake the Magician
Sequoia, Wild Animal Adventures
Terry and the Pirates
Danger Trails in Africa (Martin Johnson)
Sybil Jason in "Little Big Shot"
Tim McCoy in "The Westerner"
Og, Son of Fire
The Laughing Dragon of Oz
Billy the Kid, Outlaw of the West
Erik Noble and the Forty-Niners
Prairie Bill and the Covered Wagon